Carving
Gnomes

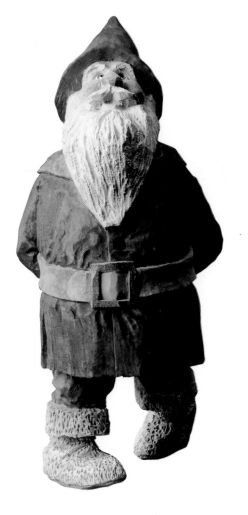

77 Lower Valley Road, Atglen, PA 19310

With Tom Wolfe

Text written with and photography
by Douglas Congdon-Martin

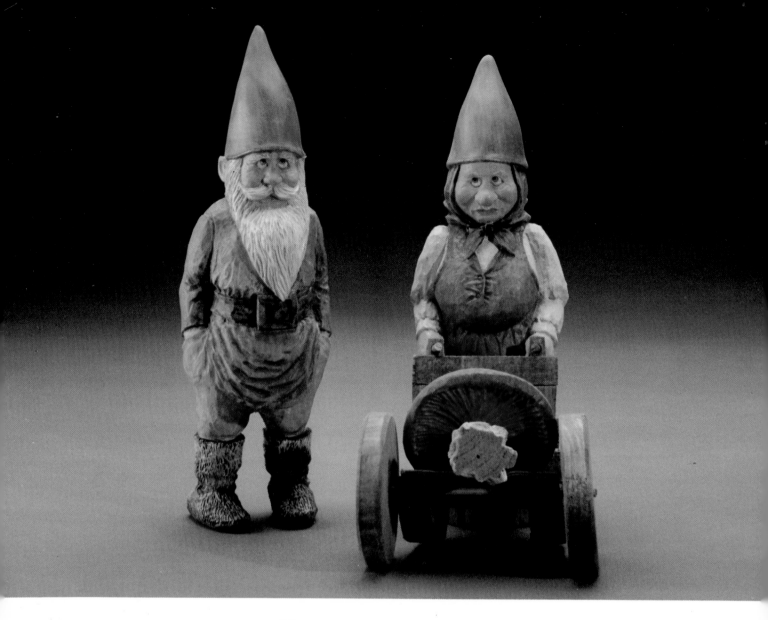

Contents

Printed in the United States of America.
ISBN: 0-88740-537-1

Published by Schiffer Publishing, Ltd.
77 Lower Valley Road
Atglen, PA 19310
Please write for a free catalog.
This book may be purchased from the publisher.
Please include $2.95 postage.
Try your bookstore first.

We are interested in hearing from authors
with book ideas on related subjects.

Introduction

While they are experiencing a renewed popularity, Gnomes have inhabited the human imagination for hundreds of years. In the earliest written reference, over 500 years ago, Paracelsus described them as beings whose element was the earth. They moved through it like fish moved through water or birds and animals move through the air.

They are the guardians of the earth's treasures. According to Norse mythology they cared for mines and miners. They dug gold and jewels from the earth, and made the shields and swords of the Norse gods.

They were known for the mischief they created.

While they were confined to the earth during the day (sunlight would turn them to stone), at night they were free to roam the surface. They tormented the wicked and aggravated the not so wicked with their tricks.

According to legend the male gnomes were quite ugly and hunchbacked, while the females gnomes were very good and beautiful. In these pages they are all charming, full of personality, with just enough impishness about them to make you wonder what devilment they are up to.

I hope you enjoy carving the figures in this book and creating your own gnomes!

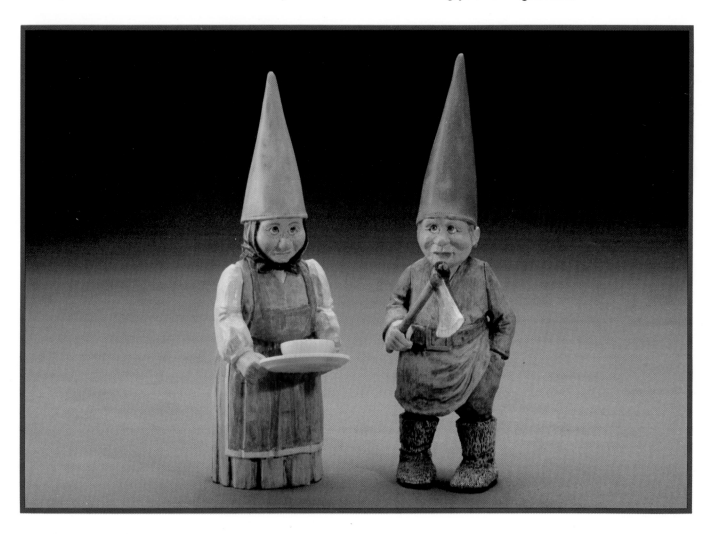

The Gnome

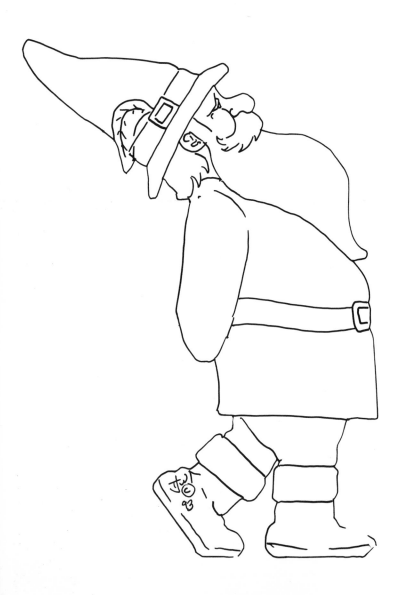

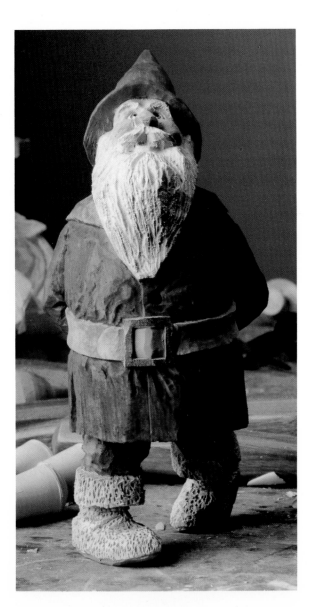

The finished gnome.

All patterns are shown at 75% of original size. To restore them to actual size, you must enlarge them 133%.

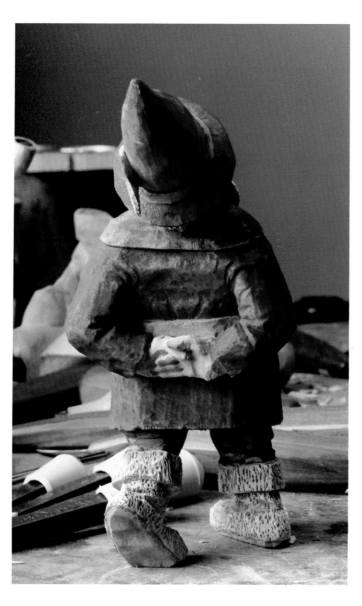
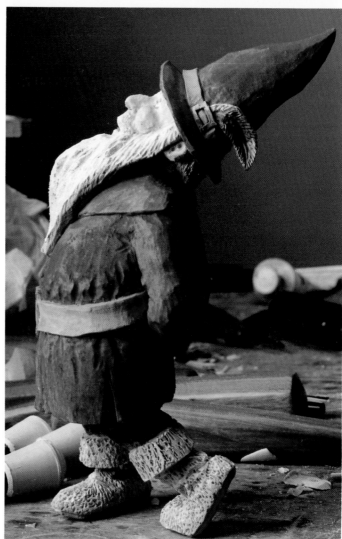
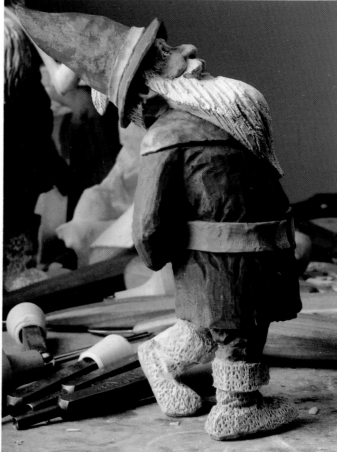

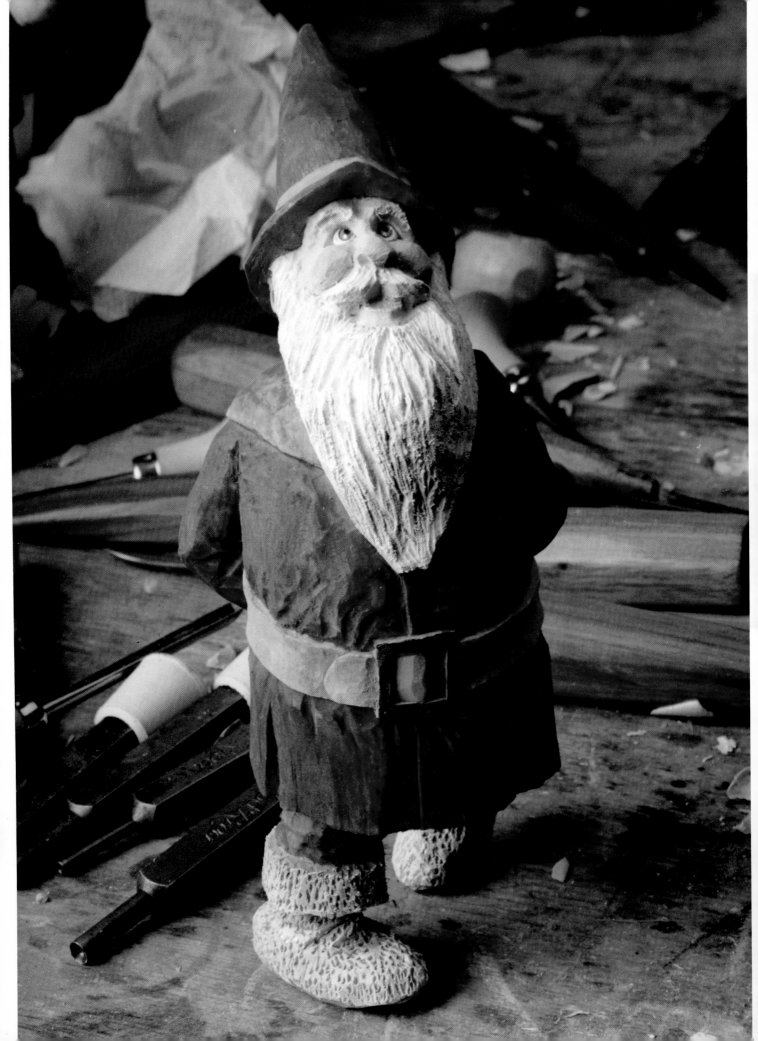

Carving the Gnome

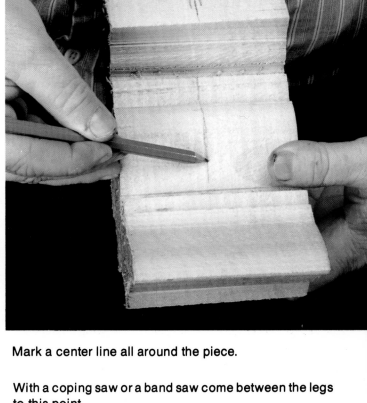

Cut the pattern from 4 inch stock.

Decide which foot is to be forward and mark the one to be removed. I want the right foot forward.

Mark a center line all around the piece.

With a coping saw or a band saw come between the legs to this point.

On the left side, mark the front of the blank to be removed.

Mark the line from the tip of the hat to the shoulders.

Mark the profile patterns on both sides.

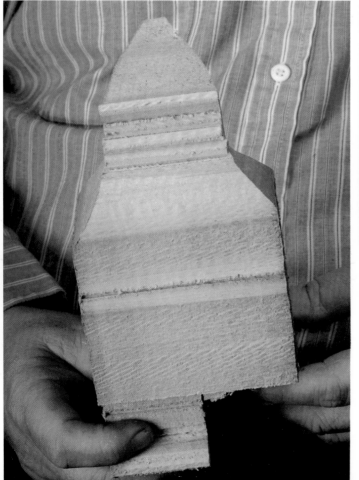

At the corners of the hat, above the brim, cut a stop straight in...

Use a band saw or coping saw to give this rough shape to the head. To remove the unwanted legs you can use a knife and carve it away, but I often use a drill press, set to the proper depth, to drill the excess wood. If you use a drill press, do it before you cut the head so the piece will sit well on the drill table.

and trim back to it.

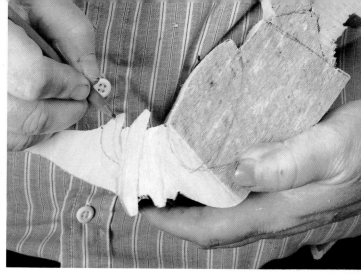

Decide on which side of the cap the feather is going to be and mark it.

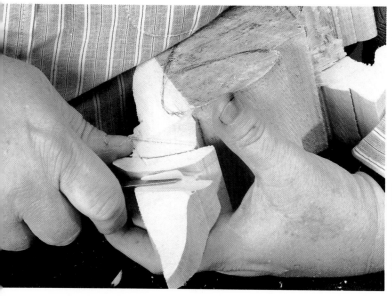

When the corners are done, continue the process in the middle of each side.

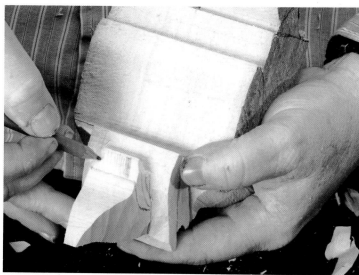

Mark its thickness on the back and darken the area to be removed.

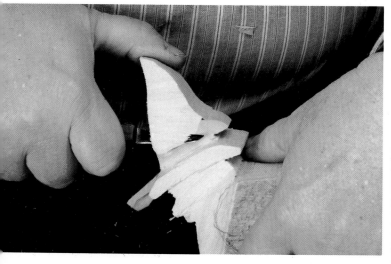

With the brim somewhat defined, continue trimming to the peak of the cap. Keep the sides square for now. I always like to go from square to octagonal to round.

At the back, make a stop on the line of the feather...

and cut back to it to remove the excess.

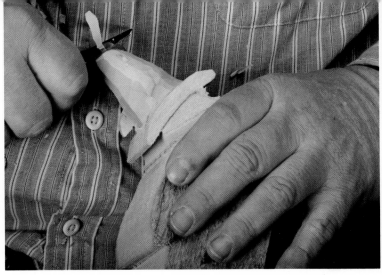

After you get the peak to octagonal, go ahead and round it off.

Now we take the peak of the cap to octagonal. Begin on the side by cutting a stop in the line of the feather and trim the corner back to it.

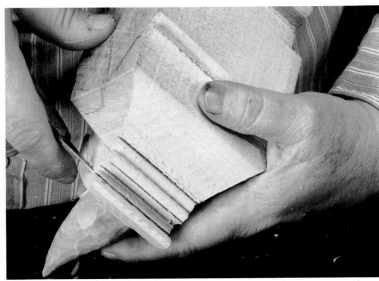

Begin work on the face by cutting stops in the corners of the underside of the brim...

Continue trimming the corner to the peak, and repeat on the other three corners.

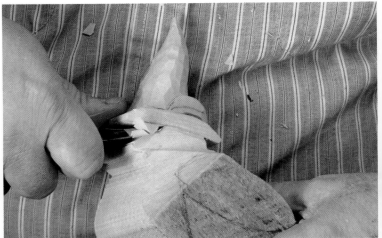

and trimming back to them from the face. The same method applies here. Do all four corners to take the face to octagonal before rounding things off.

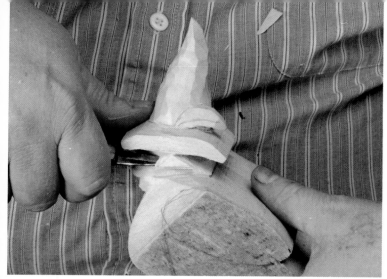

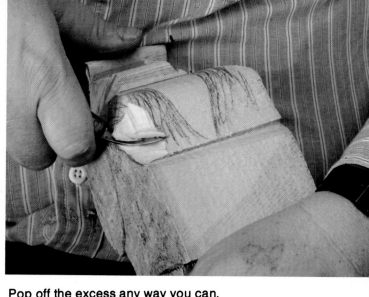

When the corners are done, use the stop and trim method for the sides. The brim in the front was cut out with the pattern.

Pop off the excess any way you can.

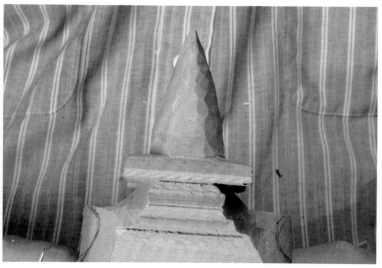

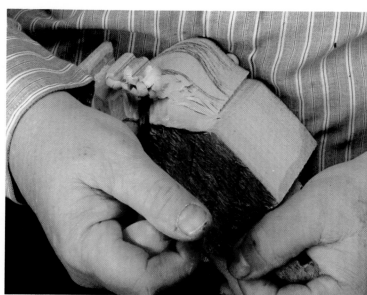

This should take you to this point, with the brim defined and the head taking shape.

I started with a knife and switched to a gouge, which seems to be working better.

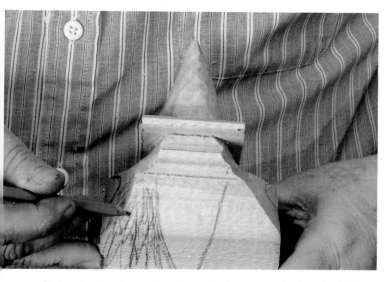

Draw in the beard and mark the area in front of the shoulder to be removed.

I return to the knife to clean up gouge marks and continue the finer work.

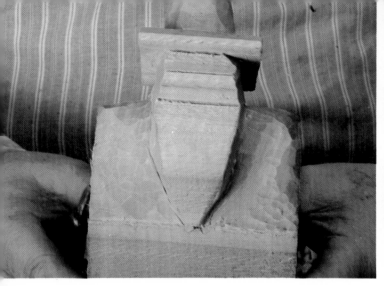

After this trimming the basic shape of the head and shoulders is established.

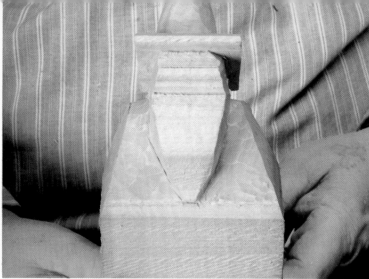

After trimming the other shoulder, the figure should be basically symmetrical.

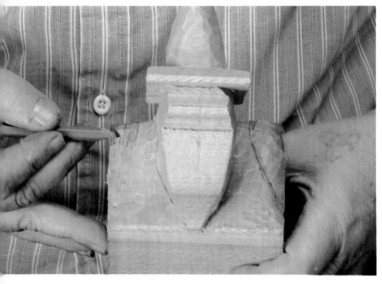

Draw in the line of the shoulders and mark the area to be removed.

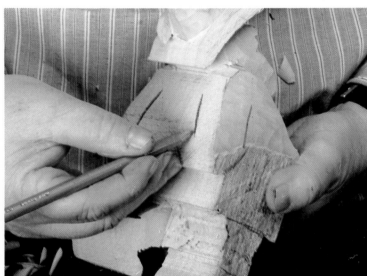

Mark the width of the arms on the side and back.

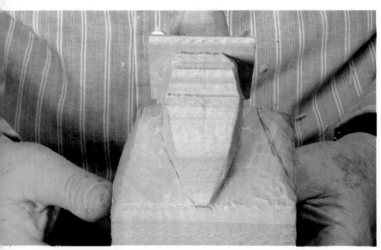

I removed the shoulder area with a knife, though it could have been done more easily on a band saw. One shoulder done.

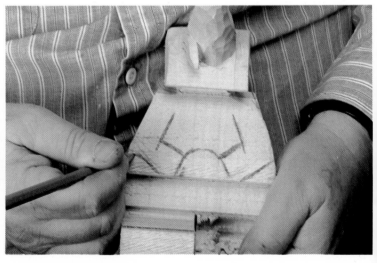

Mark the lines of the arms in back. The circle shape is where the hands will be.

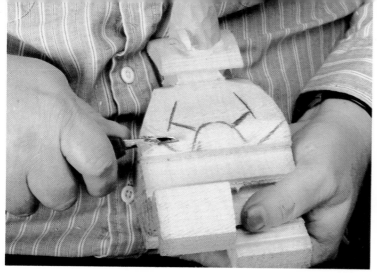

Following the line of the arm, pop off the excess wood.

and slice back to it to take out a long wedge.

Continue to about this point before repeating the process on the other side.

Continue to deepen the cut...

On the side, cut a stop in the line of the arm...

to about this point.

I want this fellow to be a little pigeon toed, so first I draw the basic line of the foot...

You can use a coping saw to cut along the line of the coat to the side of the leg. This will make the reduction of the wood much easier. Do it on both sides.

then I draw the outline of the shoe.

With the coping saw stop it is very easy to pop off the excess wood with a knife. First trim toward the coat...

Draw the width of the leg from the center line, and mark the area to be removed.

then cut down toward the foot.

The legs reduced to square.

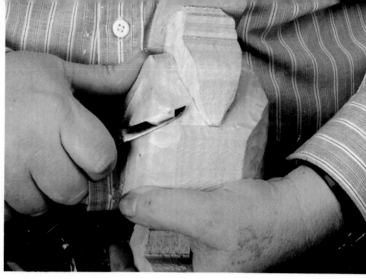

After shaping the bottom of the coat, continue the same planes onto the front upper portions, still keeping things octagonal for now.

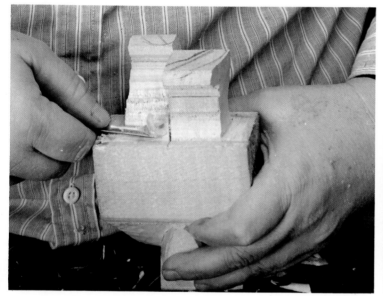

Use a gouge to clean up drill marks.

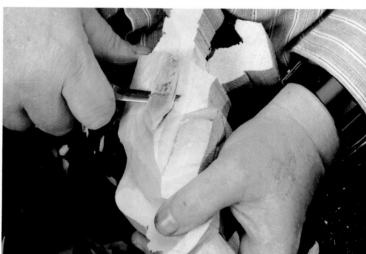

Pop down the sides to narrow the hips.

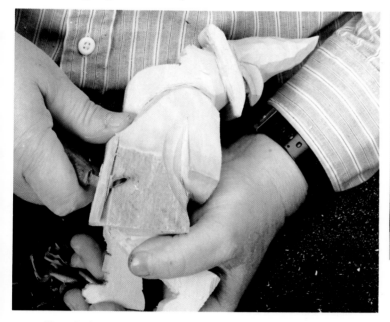

Knock the corners off the coat, taking it to octagonal.

This brings the elbows out. This is the advantage of using a 4 inch piece of wood. You can get the extreme points that give the figure character. Do the same on the other side.

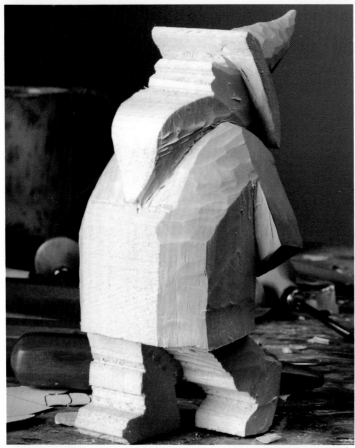

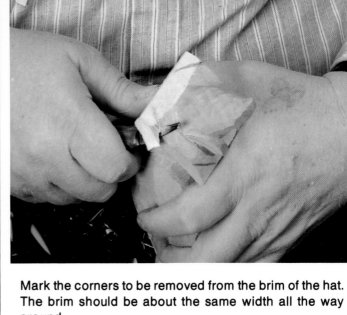

Mark the corners to be removed from the brim of the hat. The brim should be about the same width all the way around.

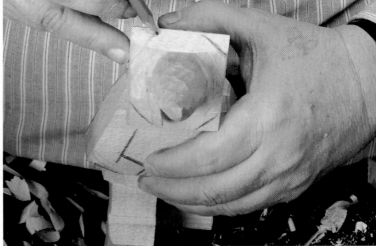

The corners should pop right off with a knife.

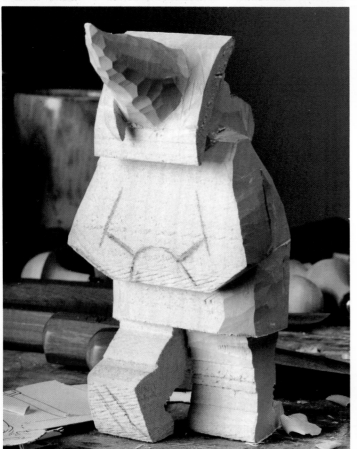

Progress report. At this point the piece should be square with no real detail. Putting in detail too soon is liable to cause the carving to move out of proportion.

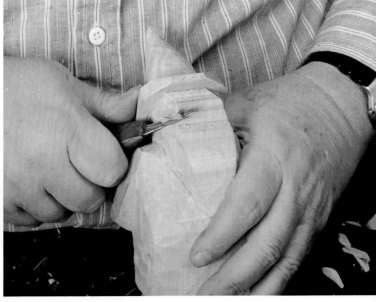

Remove the corners of the face...

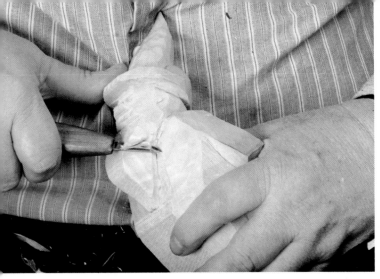

and beard.

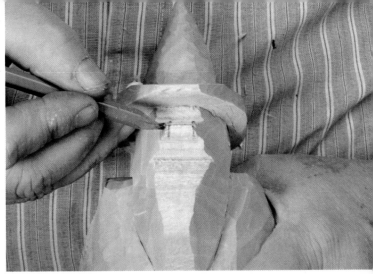

Mark the width of the nose, keeping it in the center.

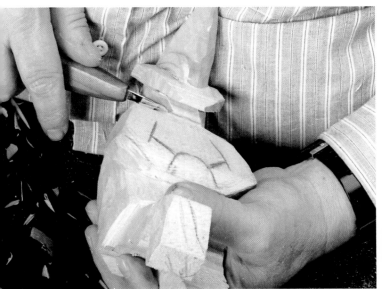

You'll have to use a kind of curl stroke to remove the corners at the back of the head under the brim.

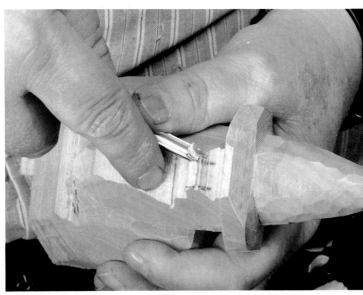

Come up the sides of the nose with a gouge to remove the excess.

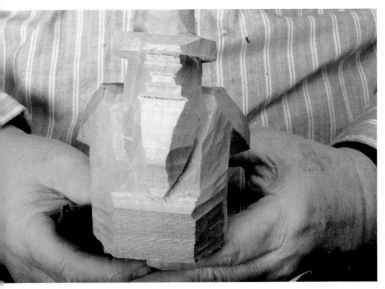

This should take the face to this point.

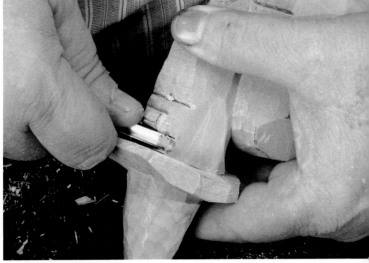

With the same gouge work out from the bridge of the nose to create the eye sockets.

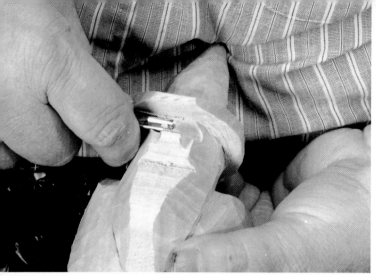

Continue to deepen the eye sockets.

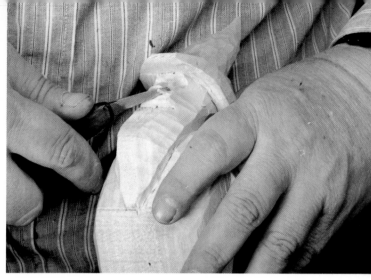

Cut in at a 45 degree angle under the nose to create the nostril.

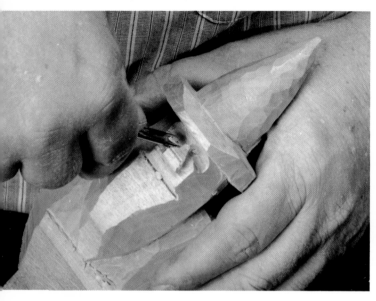

Next take your gouge up the side of the nose to the bridge.

Cut back to it from the lip to pop off the corner.

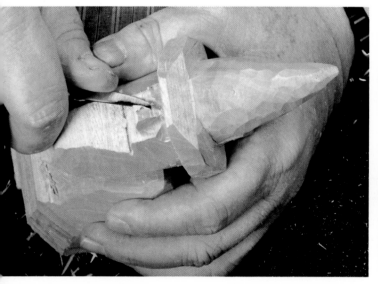

Use a knife to knock the corners off the nose.

Beside the nostril cut straight in for a stop.

Follow the cheek line with a 45 degree cut.

Mark the center of the side of the head.

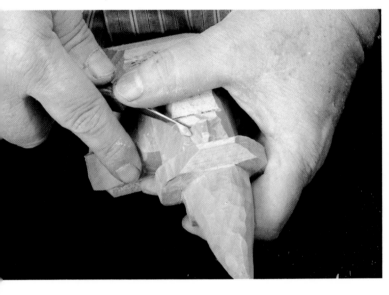

Come back to the line from the moustache and pop out the wedge.

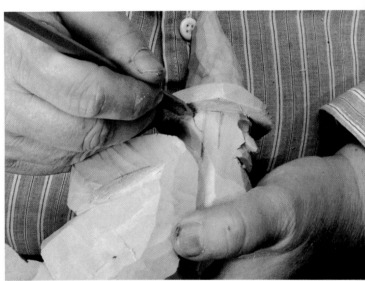

About half way between the center and the eye is the line of the sideburn, and the ear goes behind the line, its bottom edge starting at a point about even with the end of the nose.

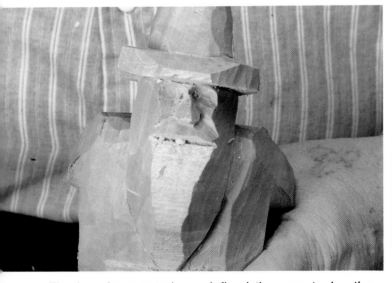

The last three cuts have defined the moustache, the cheek line, and the flare of the nostril.

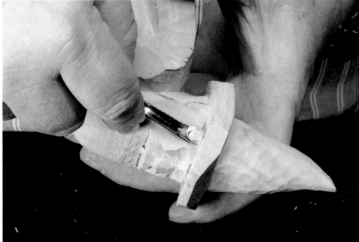

Run the gouge up in front of the sideburn line.

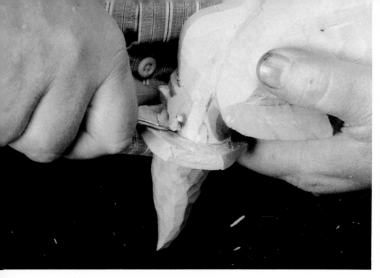

Cut off the shaving with a knife.

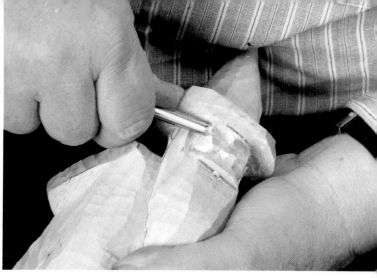

With the half-round gouge come from the temple into the eye socket, defining the top edge of the cheek.

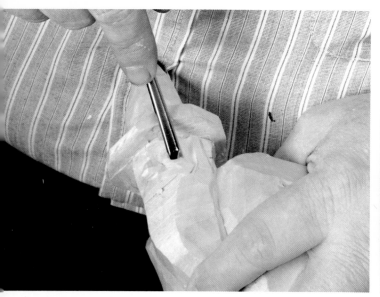

With the cup of a flatter gouge against the face, mark the line of the cheek by pushing in.

The nose seems a little to sharp for a gnome, so I'm going to go back and round it off.

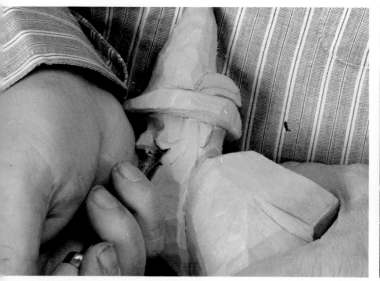

Then with the cup out, come back to the cheek line and cut off the excess.

With the cup of a gouge away from the nose, cut in to create a nostril.

Come back with a knife and remove the excess.

With a veiner follow the line of the top of the nostril to give it the definition and flare it needs.

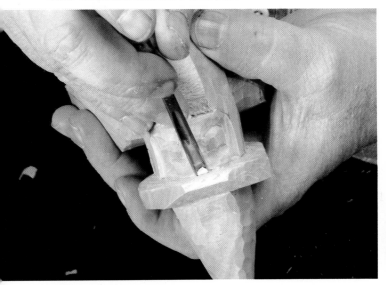

With the half-round gouge create the separation in the middle of the brow.

Pick a gouge with the sweep you want for the moustache and push it in along the bottom edge to create a curved stop. This will give it the turned up look you are seeking.

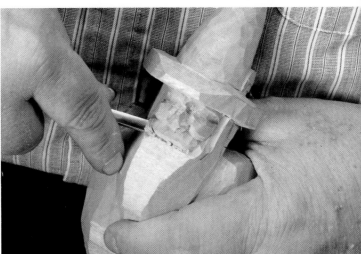

With the same gouge cut back to the stop from the beard.

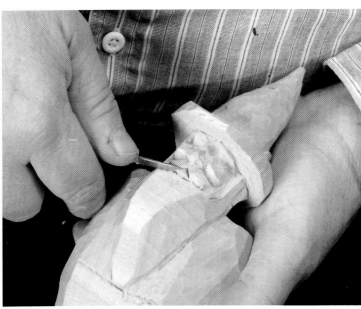

Cut a nitch between the two sides of the moustache.

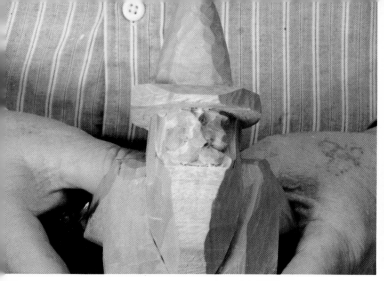

You can see the grin and moustache taking shape.

With a half-round gouge go across the beard following the line under the bottom lip. This will bring out the lip.

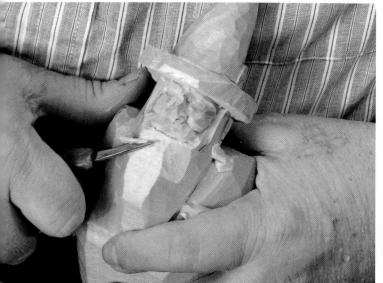

Trim the beard to create area of the chin.

Cut a stop in the back edge of the sideburn.

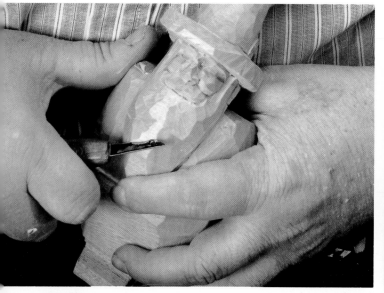

The saw marks confuse the eye, so take a few moments to remove them and shape the beard some.

Slice back to it from the ear.

Cut a stop in the back line of the ear.

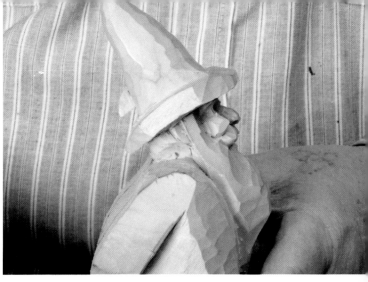

After cleaning the area with a knife it should look something like this.

Cut back to it from the neck.

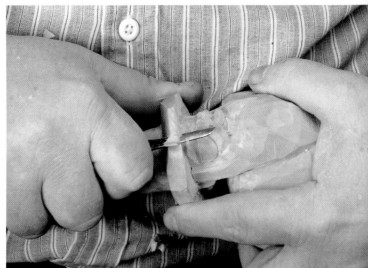

As I look at the figure I think I would like to have a narrower brim.

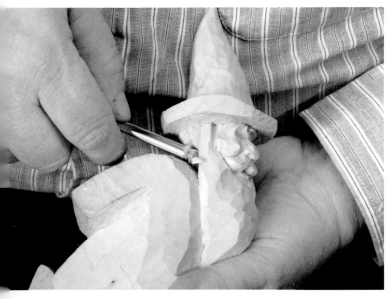

Leaving the hair at the back of the neck, use a gouge to get down to the neck behind the beard.

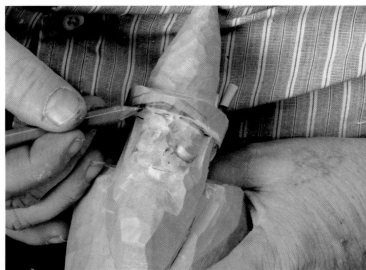

I want a little undulation in the front of the brim, so I'll mark it in now...

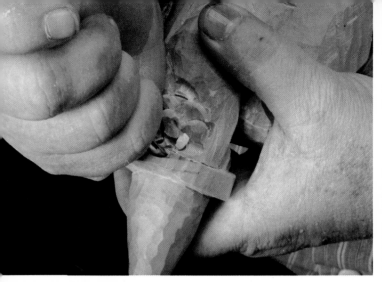

and cut away the underside with a gouge, cutting straight in.

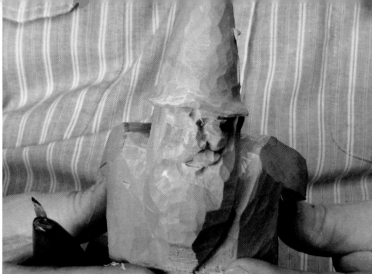

The brim carved.

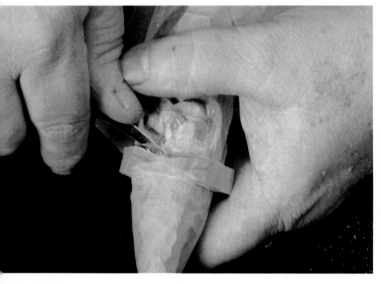

Clean up the gouged area with a knife.

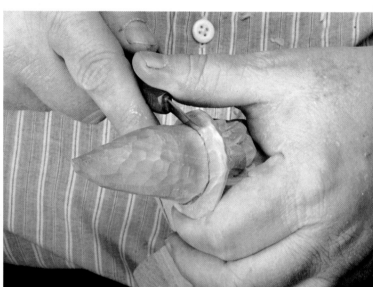

Mark the bottom line of the hat band and cut a stop in it.

Use a knife to shape the top of the brim. This surface will be somewhat concave, with the brim lower than the band.

Trim back to it from the brim.

Draw in the buckle and the top edge of the hat band.

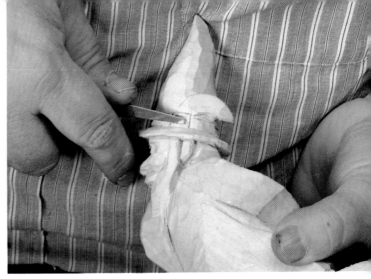

Draw the inside of the buckle, cut stops around, and trim back to them from the inside.

Make a stop all around the buckle.

Cut stops around the top edge of the band, and trim back to them from the hat.

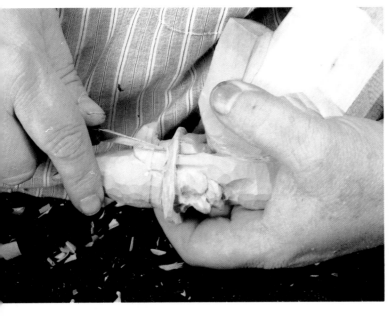

Cut back to it from the band.

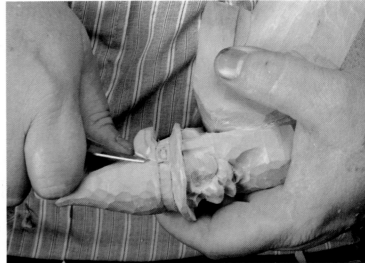

Bring out the edge of the feather by cutting a stop and trimming back to it from the hat.

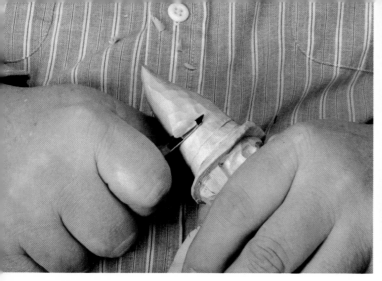

When the hat band is set, go over the crown of the hat to redefine it and be sure it is proportional.

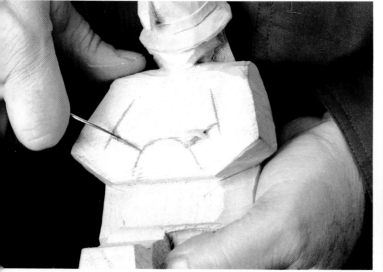

On the back, cut stops in the lines of the arm and hands.

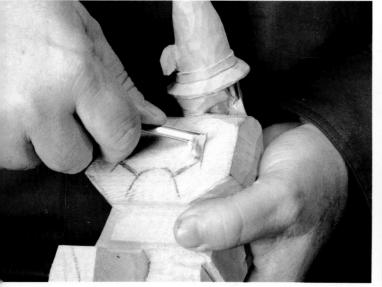

With a gouge cut back to the stops to begin removing the excess wood from the back.

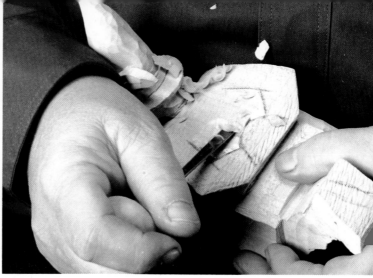

After you have defined the edges, go across the back with the gouge. You need to visualize the depth of the coat. Having the arms in the back makes it a little more difficult to get the proportions of the hands correct.

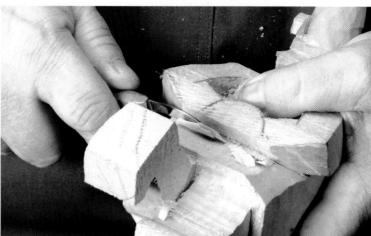

I need to bring out the bottom edge of the arms too, so I reduce the hips with the stop and cut method

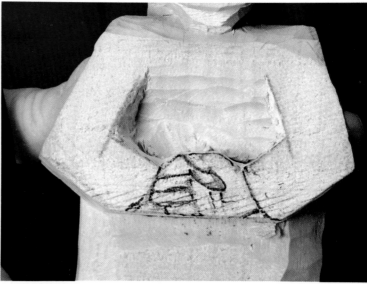

Draw the pattern of the hands clasped behind the back.

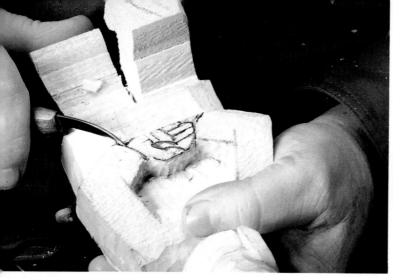

Cut a stop in the cuff.

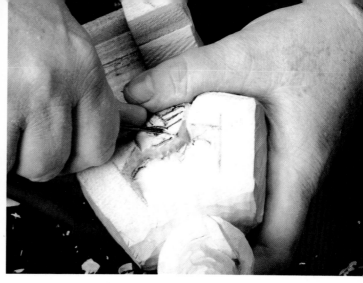

Begin defining the hand by bringing out the most forward part first. In this case it is the thumb of the figure's right hand. Follow the line of the thumb with a veiner. This gives a line for the knife to follow when cutting a stop.

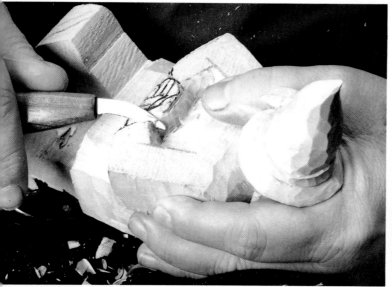

Come back to the stop from the hands, beginning at the corners.

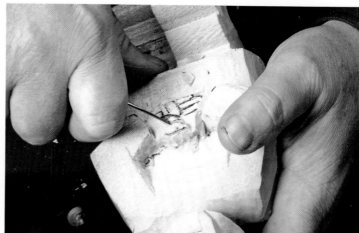

Go over the same line with a knife and make a deeper stop.

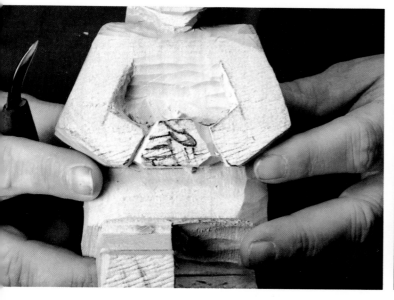

The cuffs defined.

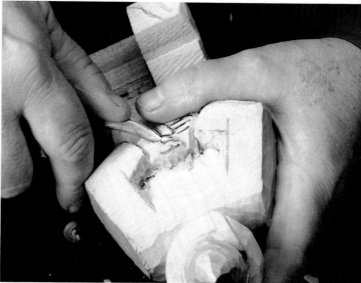

Cut back to the stop from the other thumb.

27

Moving to the thumb of the left hand, push a gouge straight in at the end of it, cup side down, to define the shape with a stop.

Deepen that line with a knife...

With the same gouge cut back to this stop from across the palm of the right hand. This shapes the palm of hand around the end of that thumb.

and slice back to it from the palm of the right hand with the knife.

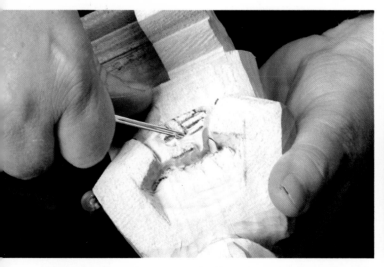

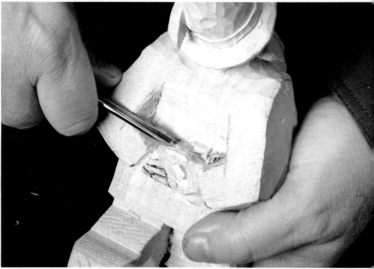

Now use the veiner to set the line along the lower line of the left thumb.

Begin to define the back side of the thumb with a large U-shaped veiner.

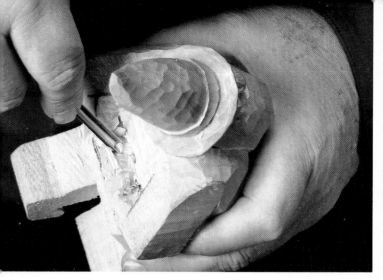

Clean the area between the hands and the back with a gouge.

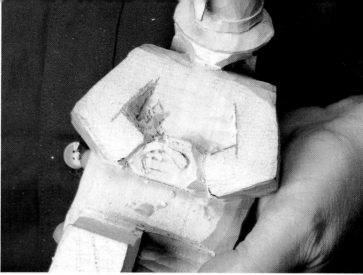

This will remove your marks, so you'll need to go back and redraw them.

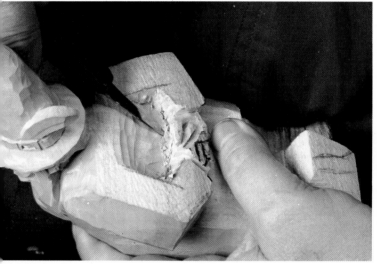

Continue the cleaning with the knife.

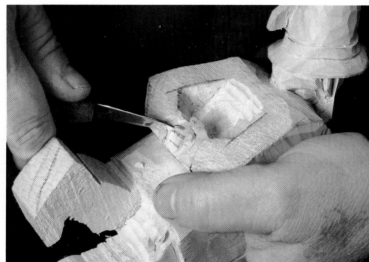

Cut a stop around the ends of the fingers.

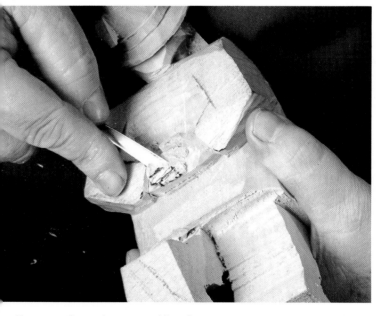

Remove the palm area with a flatter gouge.

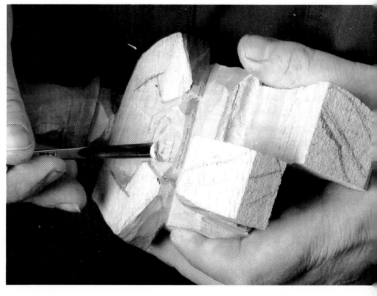

Come back to the stop with a gouge. This gives the cupped look you're after.

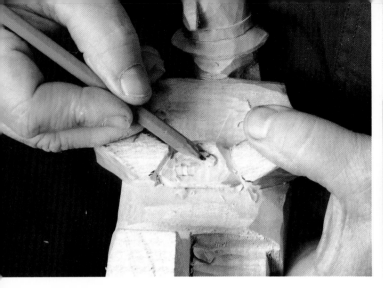

The thumb of the left hand is looking a little long, so I mark where I want to cut it off.

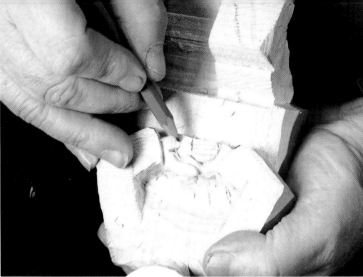

Mark some character lines on the palm of the hand.

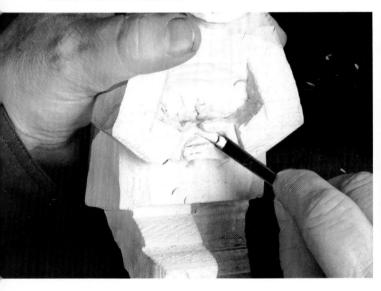

Cut a stop in the line with a half-round gouge, and trim back to it.

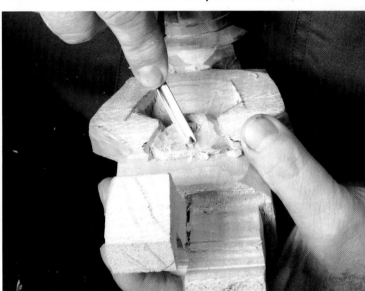

Go over the lines with a flatter gouge. This shapes them without making them too pronounced.

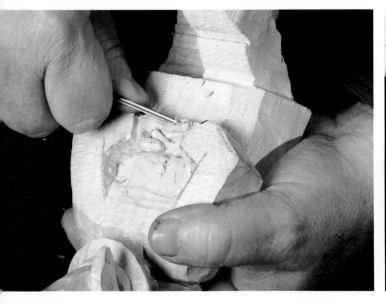

Use a veiner to form the lines between the fingers.

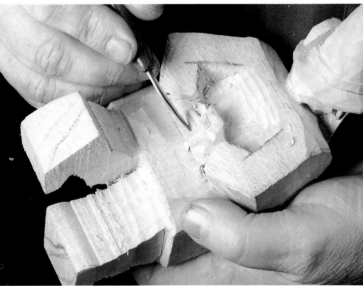

Sharpen the lines of the fingers with a knife.

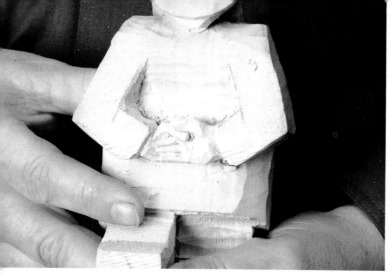

The hands. I'll come back over it with the detailer later.

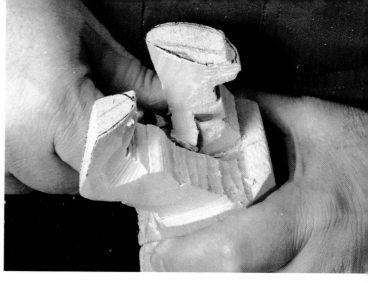

and continued from the back. All I want at this point is to create enough space to make the carving easier.

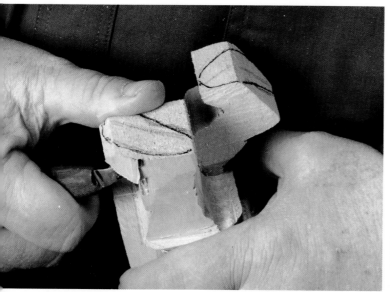

Now we move to the feet. Following the line of the shoe, pop off the excess to bring the feet to their rough shape.

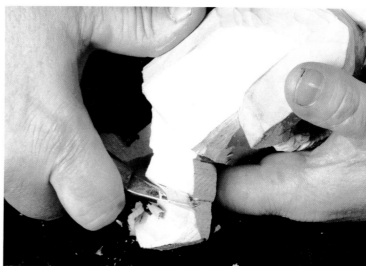

Cut a stop around the bottom of the boot's fur trim and carve back to it from the boot. Remember to start at the corners...

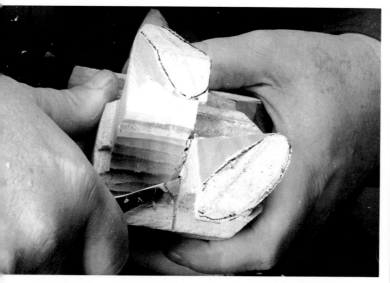

When the soles are shaped begin opening the space between the legs with a knife. I began in the front...

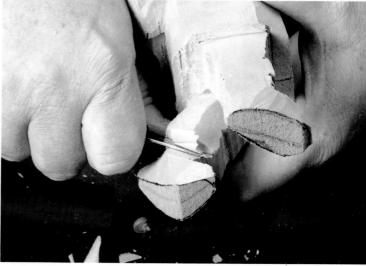

and continue around.

Carve the feet so everything aligns with the sole.

Bring the feet to shape.

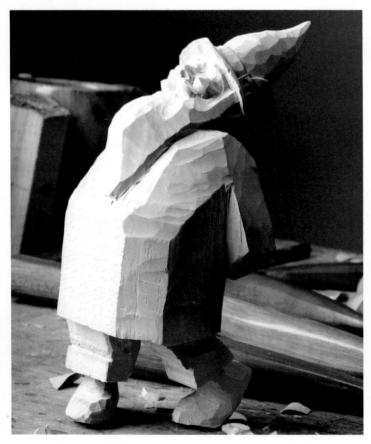

Progress so far

Mark the top edge of the fur cuff of the boot.

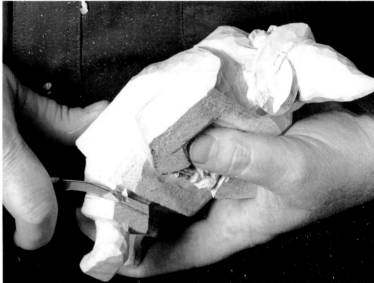

Cut a stop in this line and cut back to it from the upper leg. As always, begin at the corners.

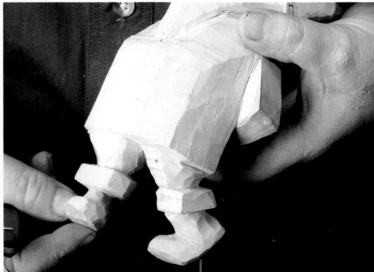

When the corners are done, shape the overall upper leg.

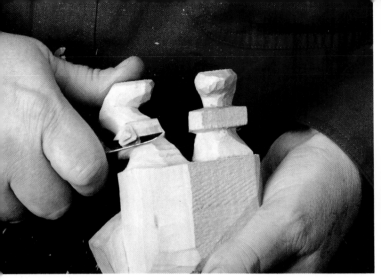

Knock off the corners of the cuffs, taking them to octagonal.

Progress.

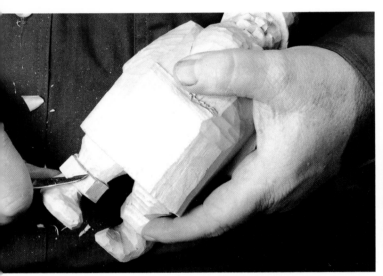

Go over the cuffs with the knife, rounding them off.

Make a major fold in the back of the knee by cutting a slice with your knife.

Now go back and thin the upper legs so they look proportional to the boots.

Three smaller slices radiate out from the fold at each end.

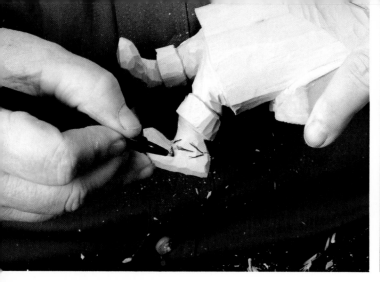
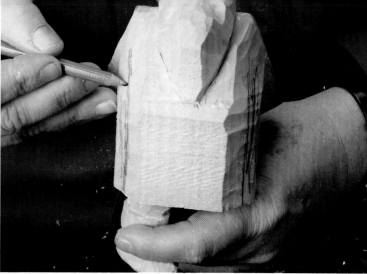

The folds in the boots are on all four sides, and follow this pattern. By the way, I usually mark the piece with pencil, not pen, because the pen can go deeper than the cut.

He needs to be a little bit narrower. Mark the area to be removed. This is pretty much according to your own taste and perception.

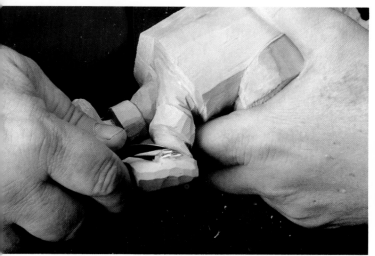
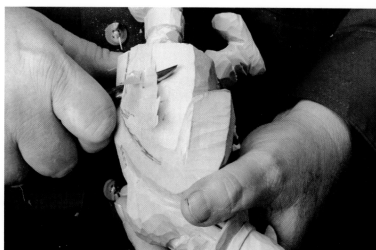

The slice I use is simply two angled cuts back to the line from either side.

Slice off the sides.

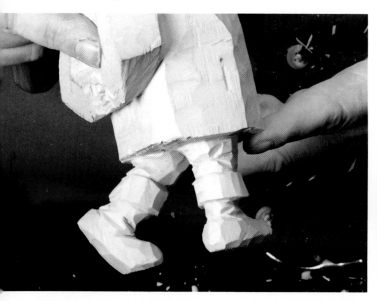
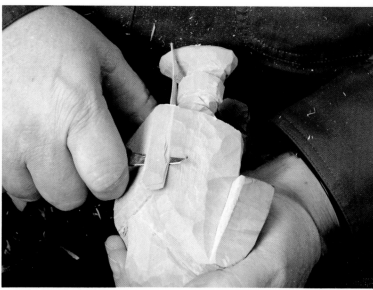

The legs and feet with folds.

After you get the body to the width you want, knock the corners off.

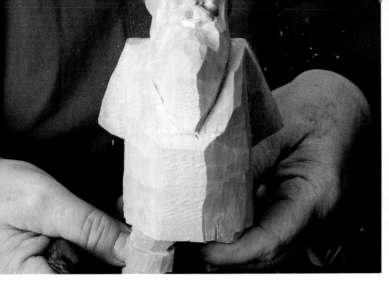

The reduced look. Carry the octagonal plane up the chest to the shoulder and leave it rough while you go back and add some slope to the shoulders.

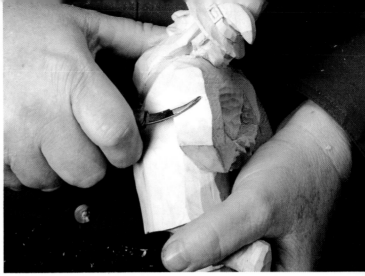

Trim the arm, keeping the surface square for now.

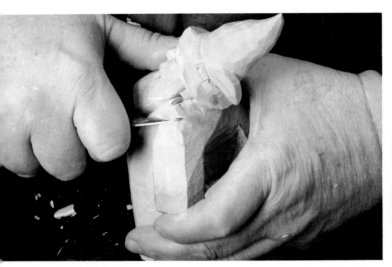

Trim the top of the shoulders.

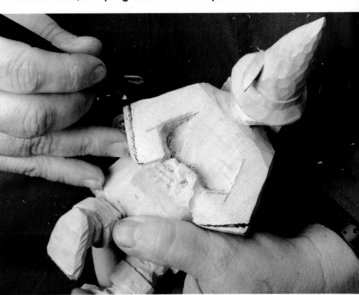

After adjusting the shoulder, we need to go back and adjust the forearm. One of the lessons of carving is that if you change one thing, you always need to go back and change five others to make everything balance again.

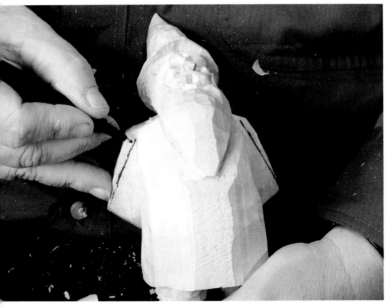

Draw a line from the elbow to the new shoulder.

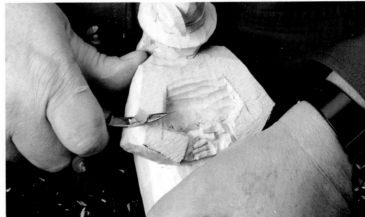

Now that all the proportions are set we can go back and round things up. Begin with the arms, knocking off the corners.

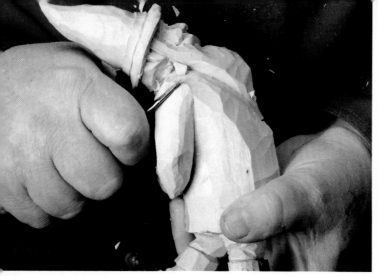

Round the arms.

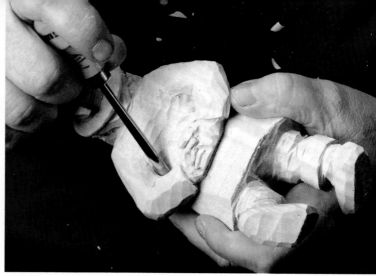

Clean out the back of the elbows with a gouge, taking a little bit at a time.

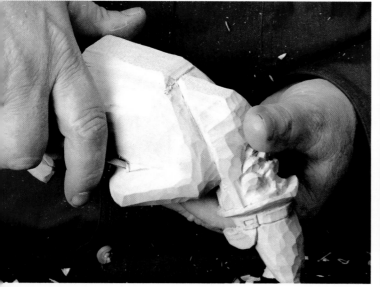

Mark the notch on the inside of the arm and chip it out.

Go over the body, rounding it off and cleaning it up.

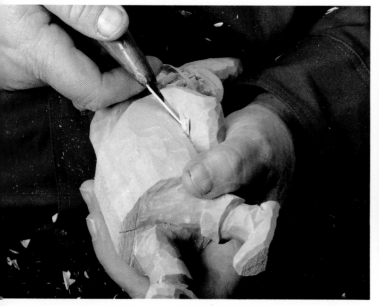

Cut from the three sides and it should come out easily.

This curved knife, with the edge on the outside, is a great tool for cleaning some of the hard to get to places, like here between the arms.

Draw in the top line of the belt and the buckle.

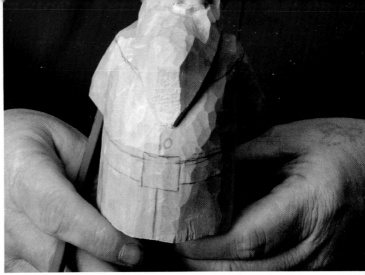

and the opening of the coat.

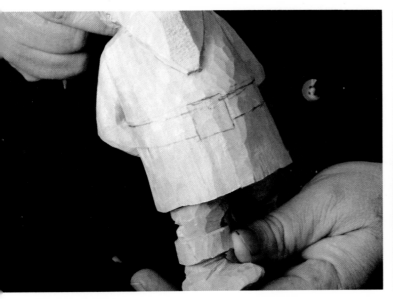

Add a parallel bottom line.

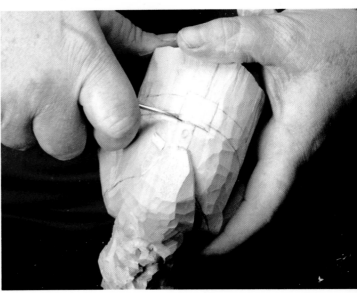

Cut a stop in the line of the buckle...

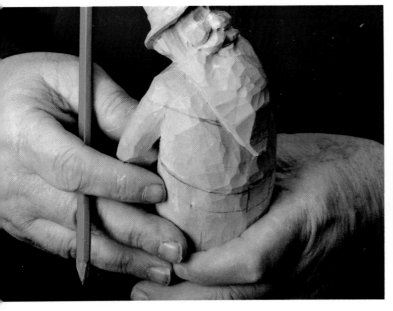

Draw in the collar...

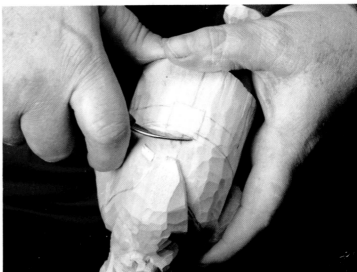

and carve back to it. Continue the process around the top and bottom edges of the belt and buckle. Don't forget to do the back.

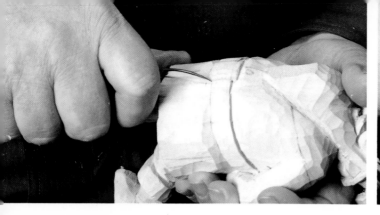

Where the buckle meets the belt cut a stop along the edge of the buckle.

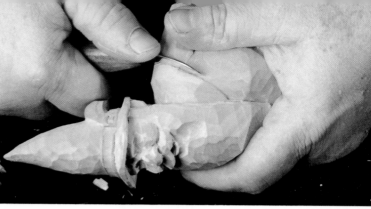

Cut a stop in the line of the collar...

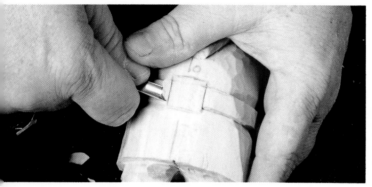

Cut back to the buckle from the belt with a gouge. This gives a cupped, natural look to the belt.

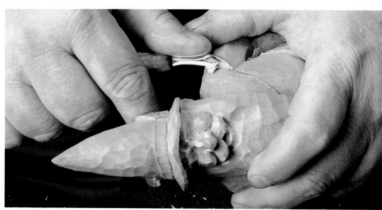

and trim back to it.

Continue all around the surface of the belt with the gouge.

Carve a slit in each side of the tunic.

Cut a stop in the line of the coat and trim back to it.

The slits need to go all the way to the legs.

Draw in the center of the belt buckle. It should be about the same depth as the thickness of the belt.

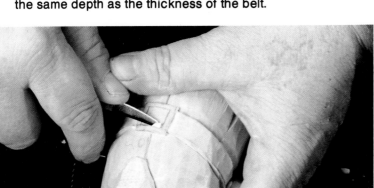

Cut stops in the corners and take a little nitch out of each one.

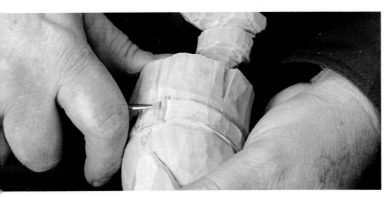

Then cut stops in the two ends and take out slices by cutting back to them. This leaves the middle portion raised.

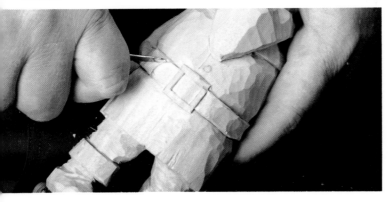

Draw the end of the belt, cut a stop in it...

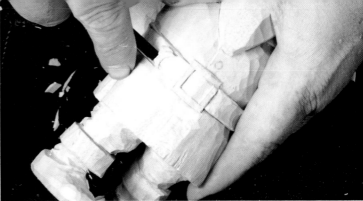

and come back to it with the gouge.

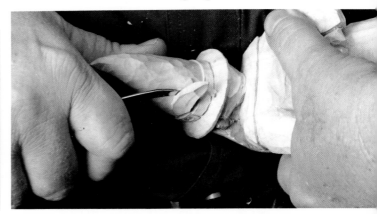

Thin the feather, starting at the back. With the head upturned the grain runs with the feather, which is a definite advantage. We want to get the feather as thin as we can.

I'll use a gouge to cup the inside of the feather. That helps the strength by leaving the thickness while making it look thin.

Go over the whole piece cleaning it up, leveling it out, looking for saw marks, and fixing any other problems. I've missed the folds in the elbows.

Ready for the detailer.

To create the cloth of the coat and the hat I use a diamond impregnated teardrop bit in a flexible shaft tool. this gets into hard to reach places and cleans them up...

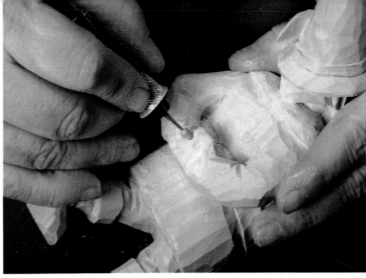

Continue with the hands.

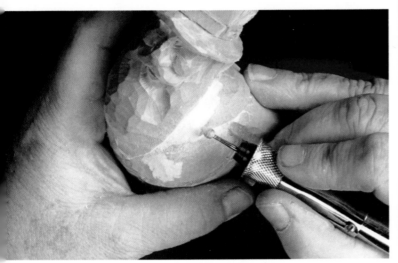

and can also be used to sand surfaces. It leaves a cloth-like appearance that I want on these figures. This tool will take away knife marks adding realism to the piece. For a more folk-like appearance, I do not use it.

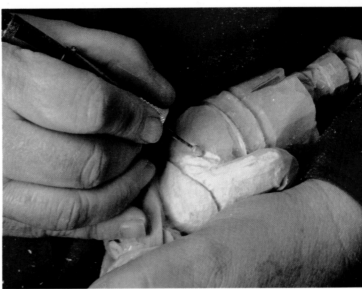

You can use the tool to add details as they occur to you, like these stress folds where the arms join the coat.

Add some folds to the front of the coat.

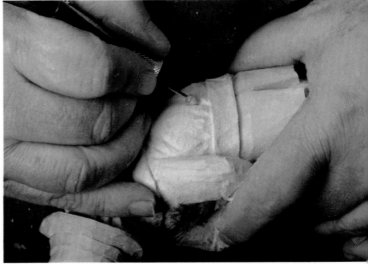

Grooves in the coat above the belt give it the appearance of being gathered.

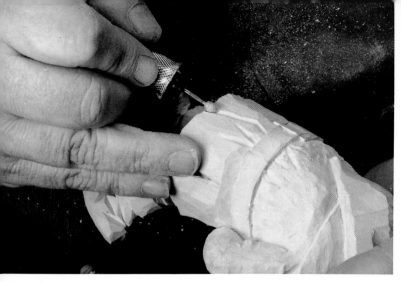

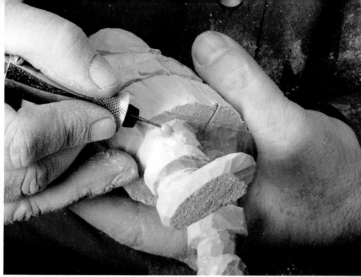

Under the belt do the same thing. Some of these folds can go to the hem. Each person has to develop their own technique for this. There isn't any certain way you have to do it.

the pants...

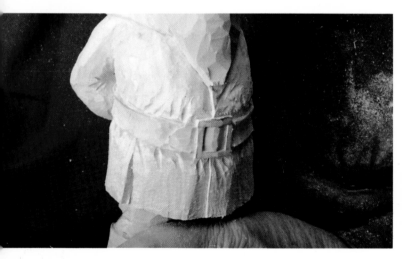

The finished coat.

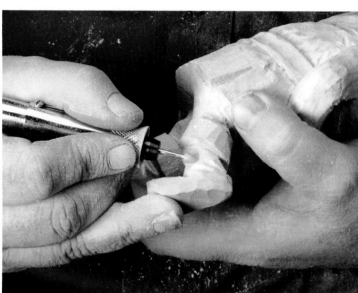

and the boots. I'll go over the boots with another tool to give it some texture, but this will take off some of the sharp edges.

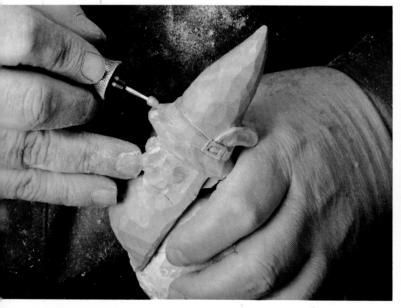

Do the same thing on the hat...

Switch to a round bit to do the face.

Go over the face, rounding every thing off. You may wish to create a few character lines.

add some hair lines like those in the eyebrows and moustache.

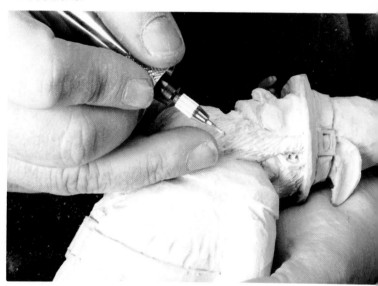

Switch to a finer bit for the details of the face. The bit is in an adapter to fit the chuck.

It can also be used on the beard...

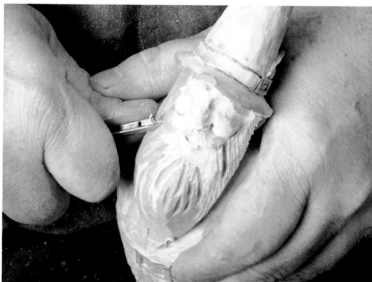

Use this to clean out the mouth...

but it's probably easier to do the major lines with a large veiner and add detail with the grinder.

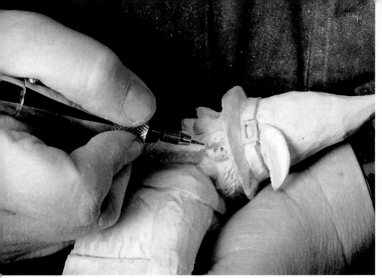

To make the inside of the ear, create a hole at the top and bottom then go around the inside of the ear.

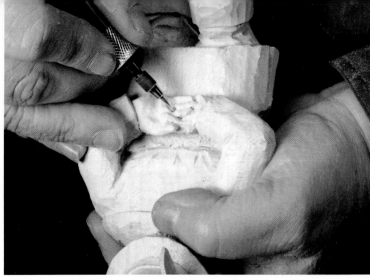

Refine the fingers and the lines of the palm.

Run a groove under the eyebrow.

I switch to this bit for the feathering.

Bring out the quill of the feather.

The flat end is what I'm looking for so I can use the edge to make the vanes of the feather.

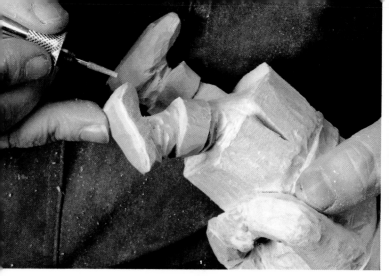

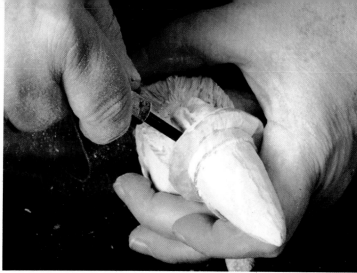

Use the same bit to go around the bottom of the boot, where the furry upper changes to a smooth leather sole.

so when I do the left eye I have a clear view of the alignment.

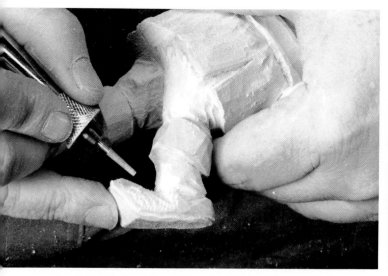

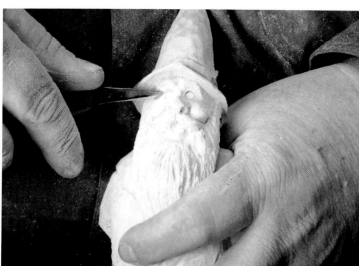

Create the fur with short jabbing motions. The fur should follow the direction that water would drain off.

On the outside of the eye cut along the top line...

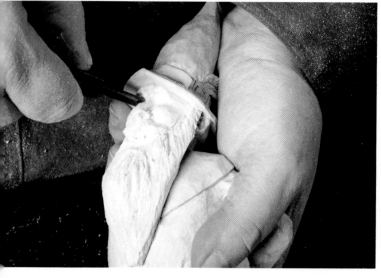

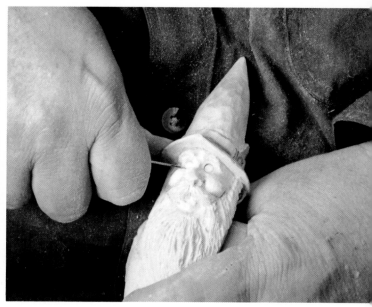

Pick the correct sized eye punch, and push and turn it into place to form the eye ball. I do the right eye first...

the bottom...

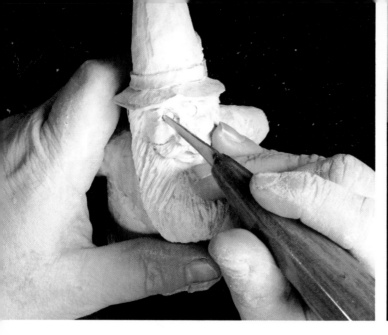

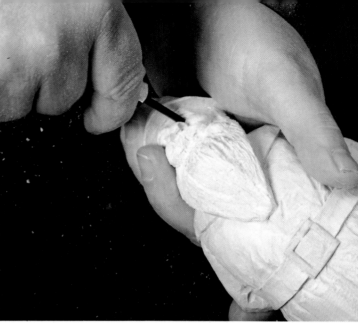

and across the iris into the corner.

Use a smaller eye punch to create the pupil. Because he is already looking up, the pupil should be centered in the iris.

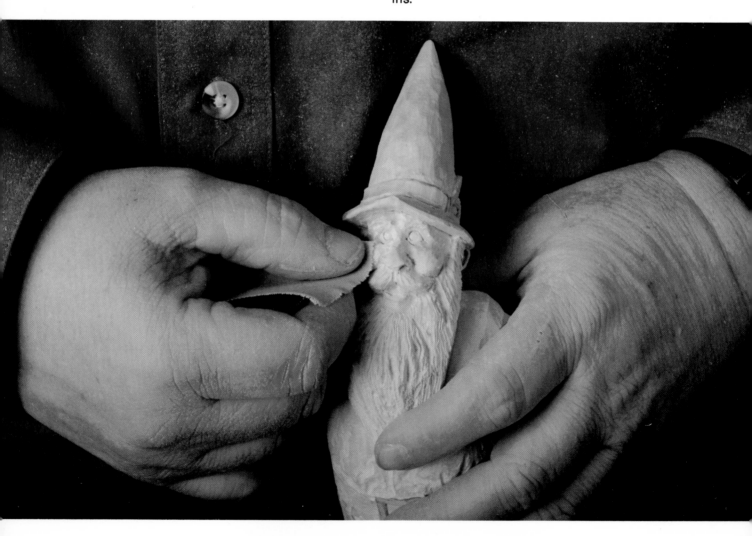

Use sandpaper to brush off some of the fuzz left by the grinding tool. In the process of doing this you may find some spots that you missed earlier.

Painting the Gnome

While painting seems to bring the Gnome to life, it is not always necessary. A natural finish is very effective. But when I do I use Winsor and Newton Alkyd tube paints. These are thinned with pure turpentine to a consistency that is soaked into the carving, giving subtle colors. What I look for is a watery mixture, almost like a wash. In this way the turpentine will carry the pigment into the wood, giving the stained look I like. It has always been my theory that if you are going to cover the wood, why use wood in the first place. It should be noted that with white, the concentration of the pigment should be a little stronger.

I mix my paints in juice bottles, putting in a bit of paint and adding turpentine. I don't use exact measurements. Instead I use trial and error, adding a bit of paint or a bit of turpentine until I get the thickness I want.

The juice bottles are handy for holding your paints. They are reclosable, easy to shake, and have the added advantage of leaving a concentrated amount of color on the inside of the lid and the sides of the bottle which can be used when more intense color is needed.

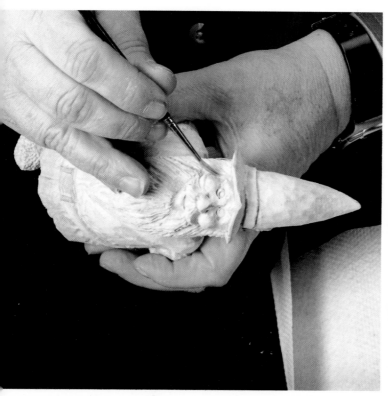

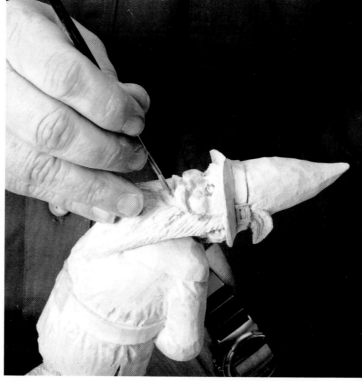

Painting begins with flesh tones on the face, ears, mouth, neck, and hands. The paint I use for this is a mixture of tube flesh, white, and raw sienna.

Add touches of red to the cheeks, nose, mouth, ears...

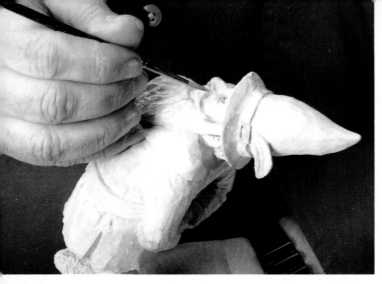

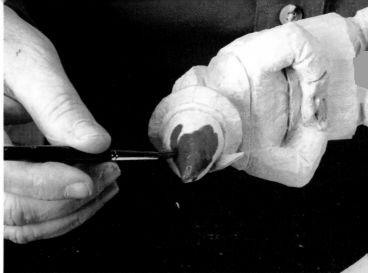

and work it in to give him a ruddy, rosy-cheeked appearance of someone who spends a lot of time outside.

I'll use a dark, alizarin crimson for the hat.

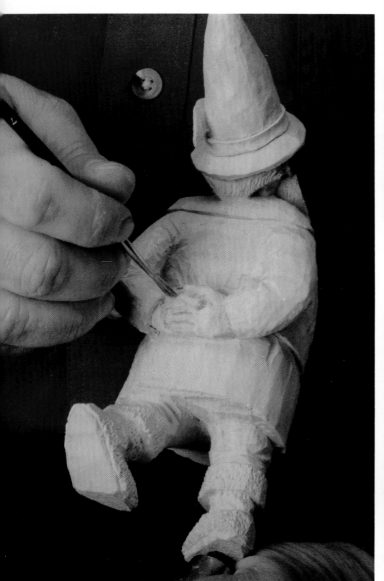

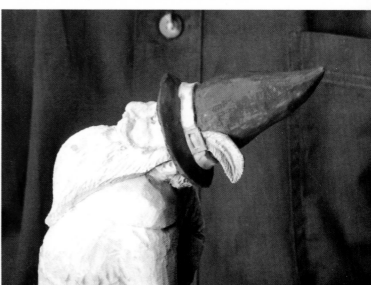

Progress.

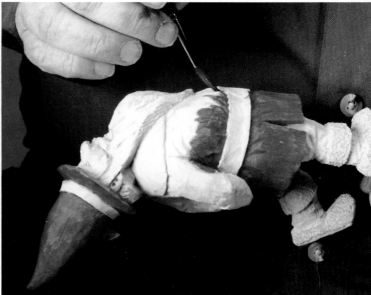

A little red on the hand is a nice touch too.

Continue the red on the coat.

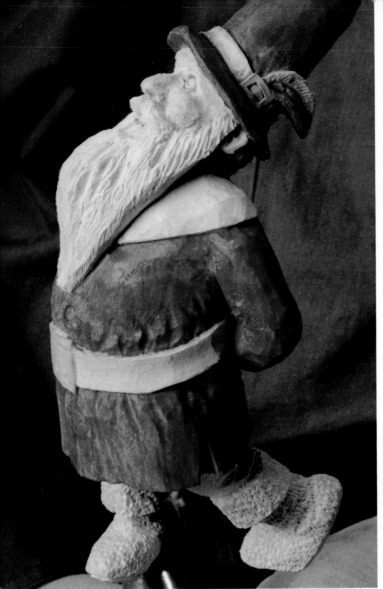

Progress.

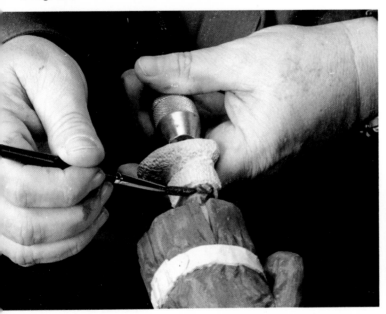

I use a mixture of blue with a touch of purple for the pants...

to go over the red of the coat...

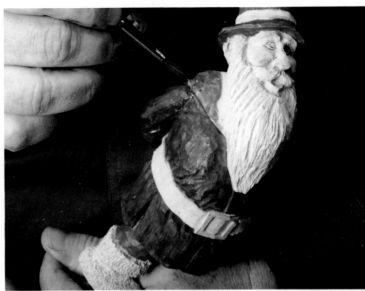

and the collar.

You may wish to rub off some of the excess paint from this second, blue coat.

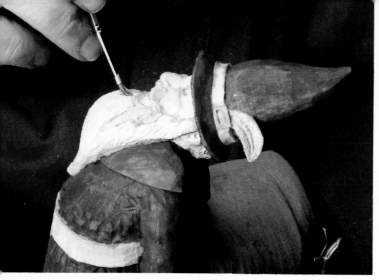

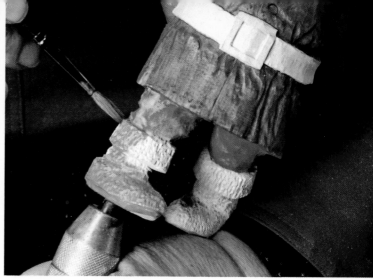

Switch to gray for an undercoat on the beard, eyebrows and hair.

Raw sienna is an undercoat for the shoes.

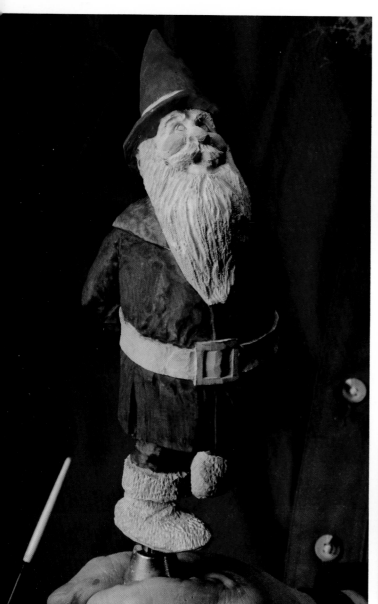

Continue with this color to the belt...

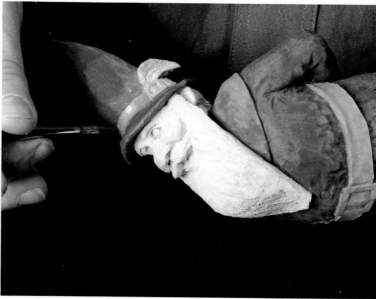

Progress

and the hat band.

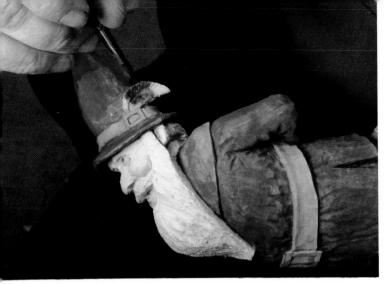

Burnt sienna for the feather. I'll leave the ends unpainted for now, so I can paint them white later.

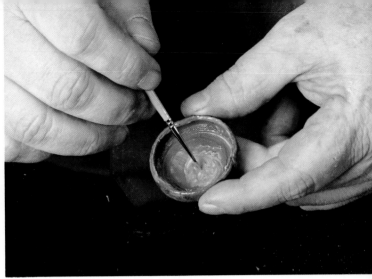

Mix a little white in the blue for the iris.

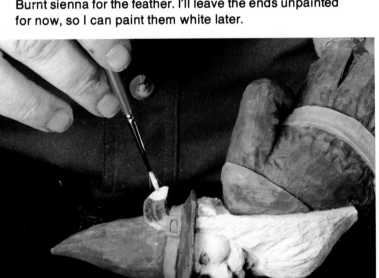

Take white paint from the cap where the pigments are more concentrated and do the ends of the feather.

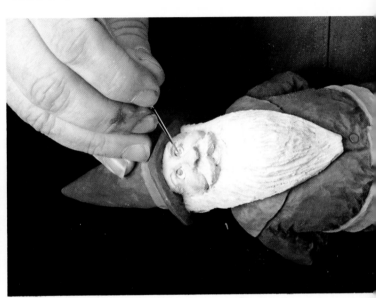

Apply it with a small brush.

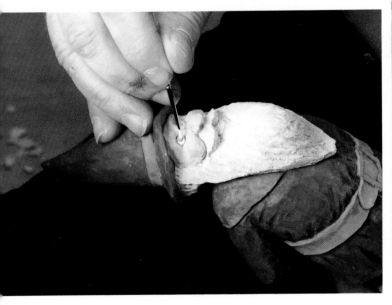

Use the same concentrated pigment on the eye.

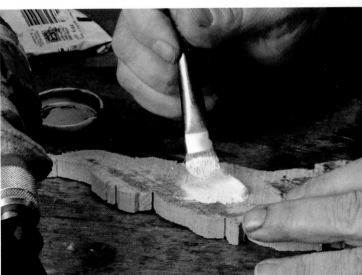

Use white paint from the tube for dry brushing over the beard, hair, and boots. Use a flat brush with the bristles cut short and saturated with paint to do the dry brushing.

Brush it across the grain. This leaves paint just on the highest ridges of the carving and gives a tipped effect.

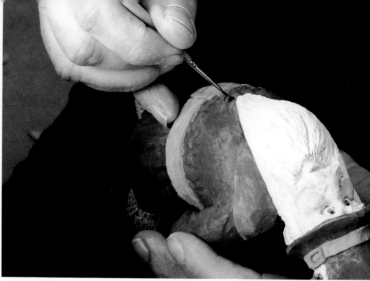

The black also goes on the button.

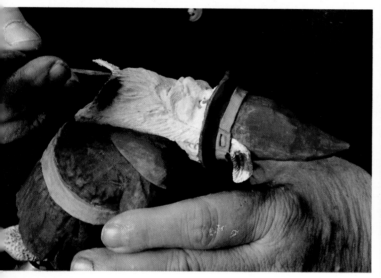

Repeat the process on the beard.

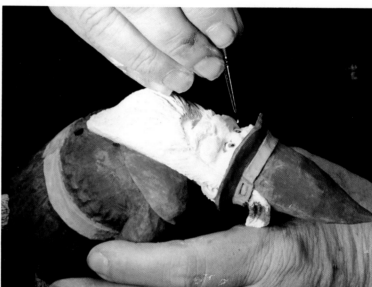

A dot of white in each iris brings life to the eyes. The dots should be in the same position in each eye.

A spot of black goes in the pupil of the eye.

A metallic pen finishes the buckle of the belt and the hat band.

Gallery of Gnomes

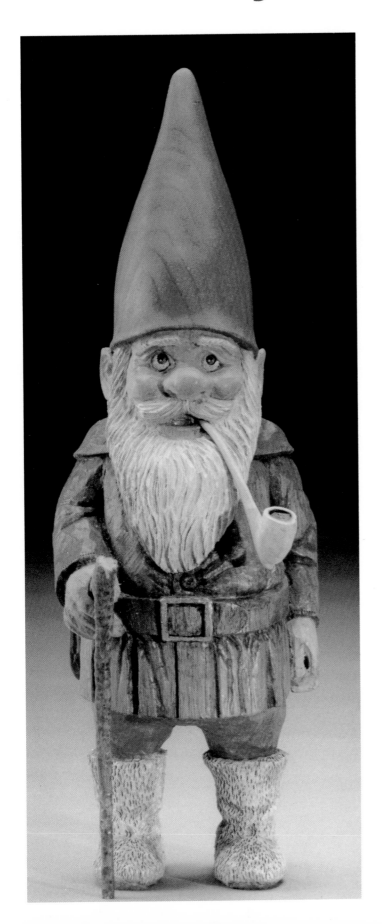 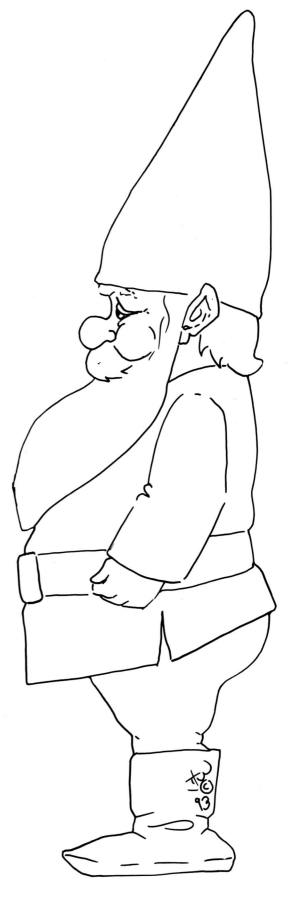

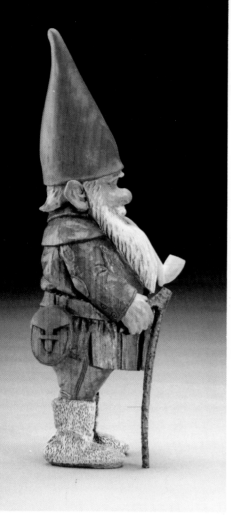

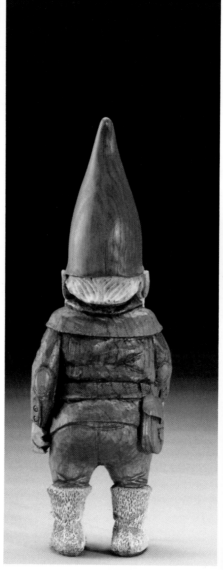

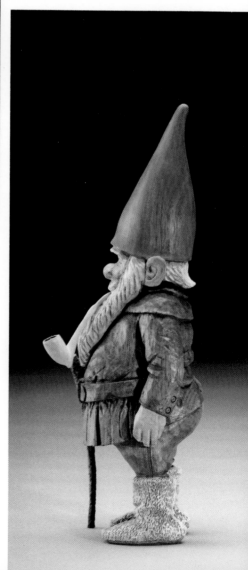

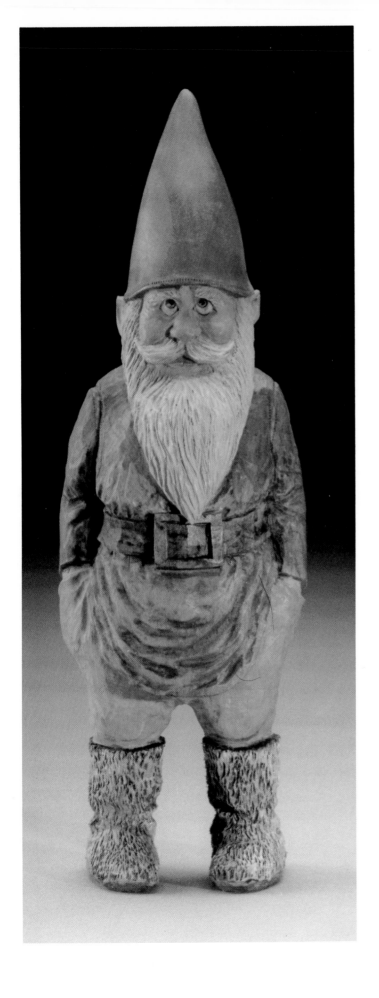
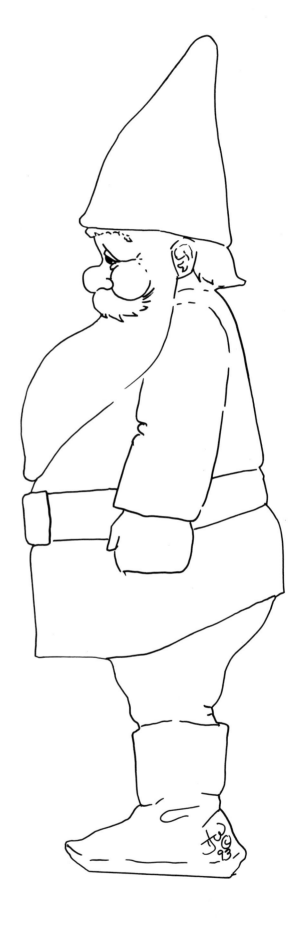

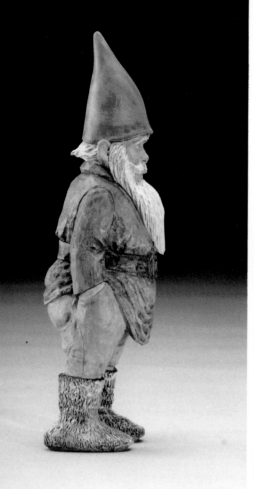

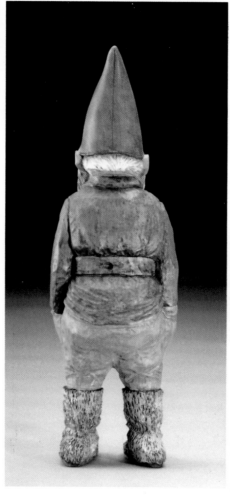

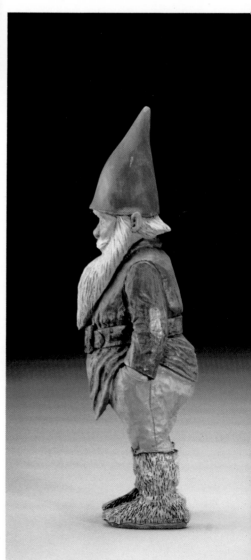

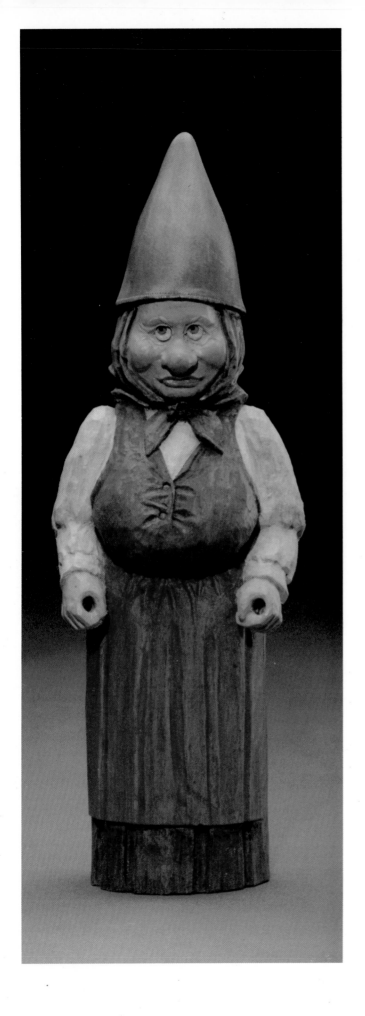
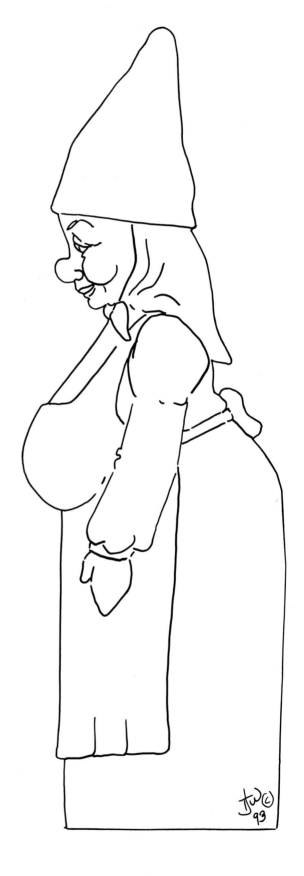

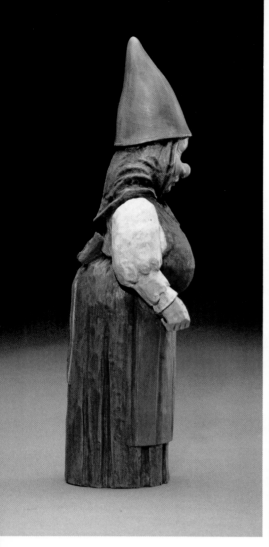

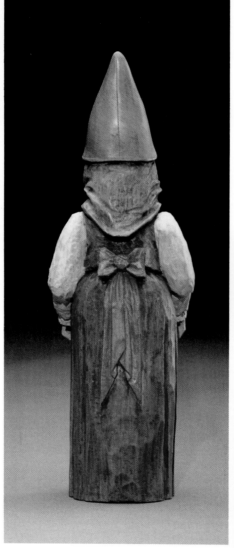

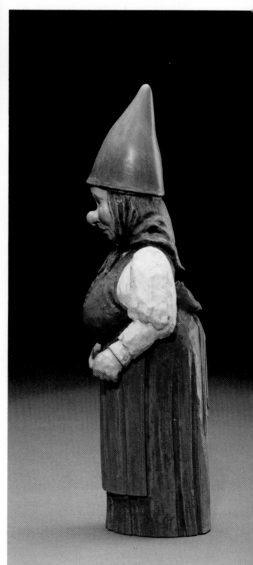

58

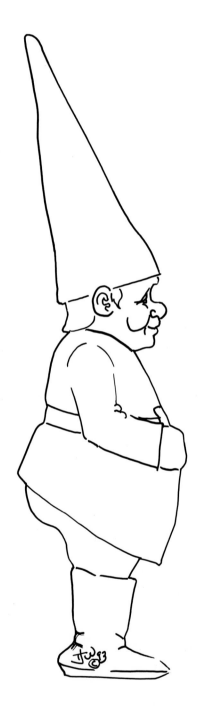

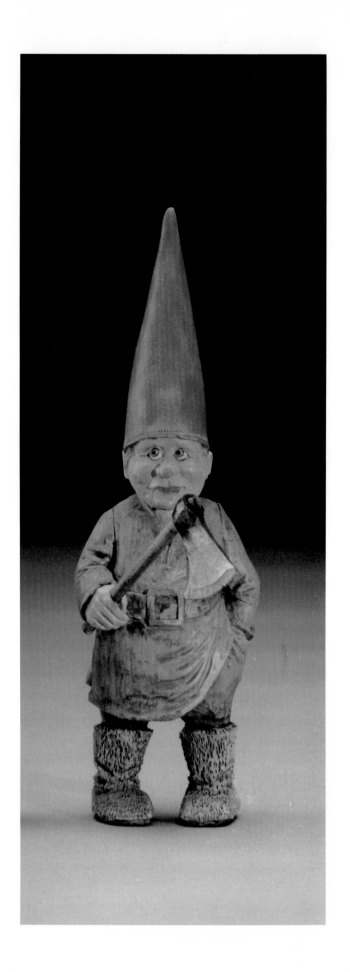

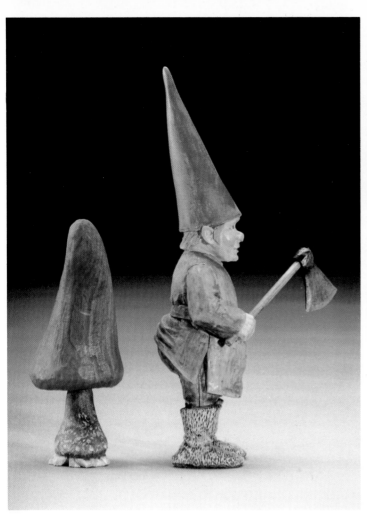

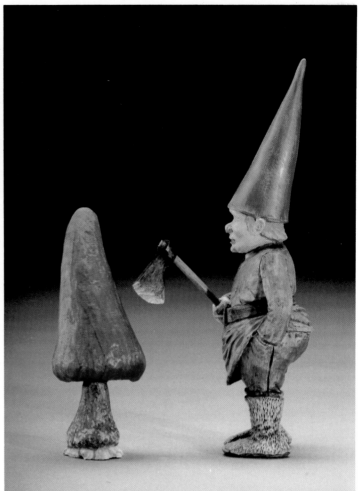

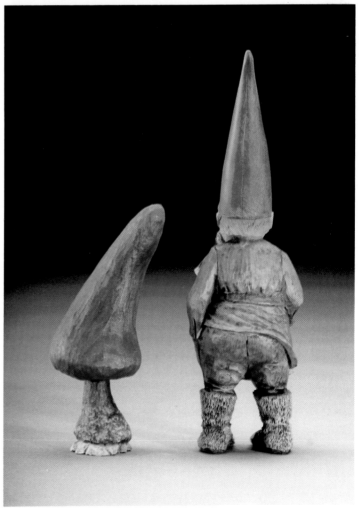

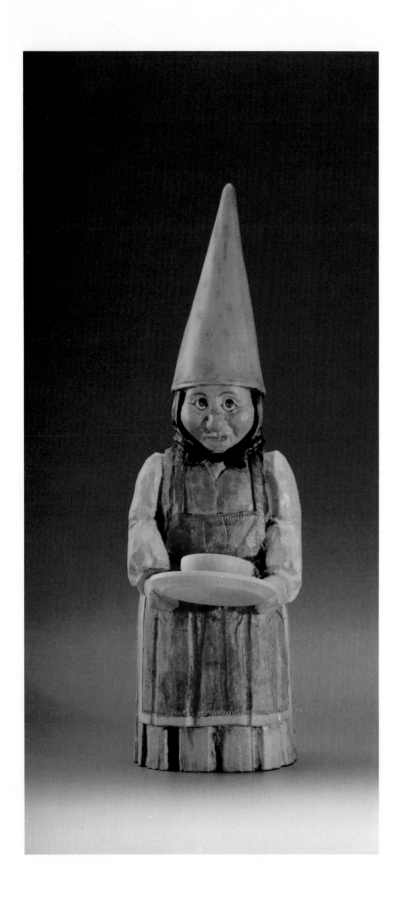

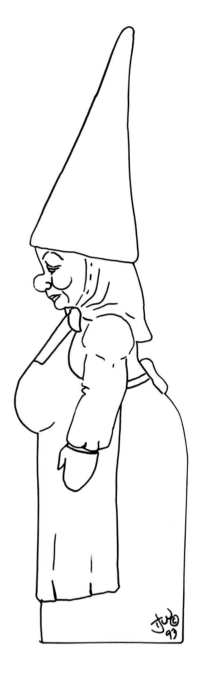

If you want to have the bowl in her hands,
you will have to move her arms up.

62

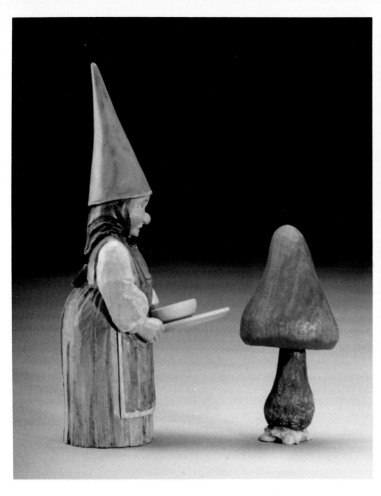

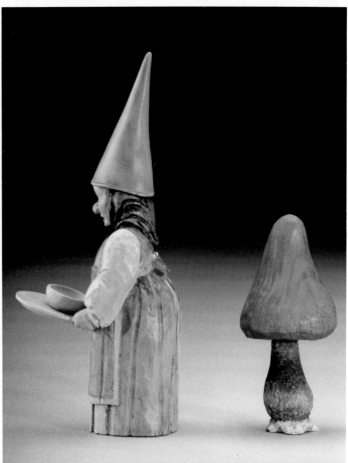